URBAN
Sketching and Painting

BARRON'S

First edition for the United States, its territories
and dependencies, and Canada published in 2015
by Barron's Educational Series, Inc.

English-language translation © copyright 2014
by Barron's Educational Series, Inc.
English translation by Michael Brunelle and Beatriz Cortabbaria

Original Spanish title: *Dibujo y Pintura Urbana*
© Copyright 2014 by ParramónPaidotribo, S.L.—World Rights
Published by ParramónPaidotribo, S.L., Badalona, Spain

All inquiries should be addressed to:
Barron's Educational Series, Inc.
250 Wireless Boulevard
Hauppauge, New York 11788
www.barronseduc.com

ISBN: 978-0-7641-6718-8

Library of Congress Control
 Number: 2013945929

Production: Sagrafic, S.L.
Editorial Director: María Fernanda Canal
Editor: Maricarmen Ramos
Text: Gabriel Martín Rig
Exercises: Gabriel Martín Rig,
 Marché Gaspar, Óscar Sanchís,
 and Esther Olivé Puig
Corrections: Roser Pérez
Collection Design: Toni Inglés
Photography: Estudi Nos & Soto
Layout: Estudi Inglès

Printed in China
9 8 7 6 5 4 3 2 1

URBAN
Sketching and Painting

Contents

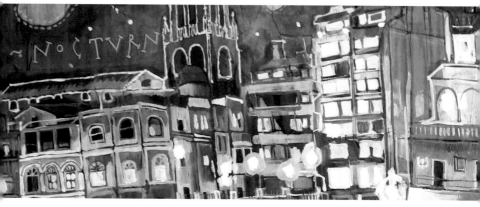

Introduction: A Most Familiar Environment, 6

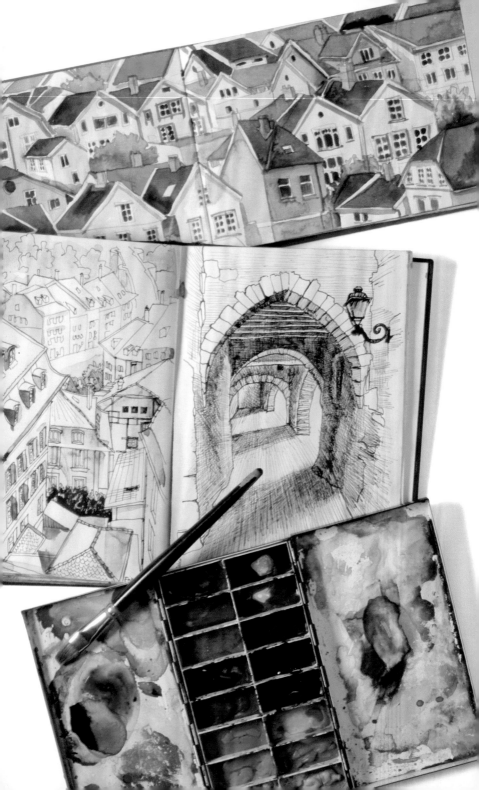

A Most Familiar **Environment**

Since the middle of the 19th century, large cities have doubled and even tripled in population, and they have been notably transformed, remodeling their infrastructure, such as train stations and airports, factories, markets, and theaters. They have redesigned, in other words, their urban spaces. The character of the city, be it ancient or modern, commands the undivided attention of artists interested in understanding the urban phenomenon and using it as the main theme of their drawings and paintings. The city can be understood as a process of humanizing nature—that is, transforming a natural ecosystem into an artificial one.

For many artists, the city is a very attractive environment, and the nearest and most immediate subject for painting. After all, a large percentage of the world's population lives in cities; a much smaller number of people live in the country or rural centers. But, even while cities are the daily environment for many, they represent a technological scene that is theatrical and dynamic, and very fascinating, variable, and changing. Obviously, this is so because of the variety of shapes and structures that compose cities—the diversity of colors, surfaces, and textures that radiate an almost hypnotic power, even more so at night.

Therefore, the urban landscape is never a generic or boring subject. To the contrary, it is quite dynamic because it offers an opportunity to include the natural vegetation of a park, the architecture of buildings, and the hustle and bustle of people and vehicles in a single work of art. The city is a subject that can become a meeting point for different artistic genres.

This book encourages reflection on the way we see and study the urban landscape. It offers a series of exercises done in a variety of techniques and based on multiple interpretations, using many artistic media, which will improve your artistic results in surprising ways.

Getting Acquainted with **the City**

For those of you who are interested in urban landscapes, and who also live in a city, any minimally attractive architectural detail can become an excellent opportunity for painting. All you have to do is open the window and lean out to contemplate the surprising spectacle of the geometric structures that are in buildings: the reflections of sunlight on the windows, the balanced structures, the ornamented façades, and the flashing lights of the different businesses. Looking out the window to contemplate the city is not just a whim. Many artists believe that elevated points of view—like windows, balconies, and rooftops— help to give them a better view of the subject so that they can more accurately paint the receding streets, better frame the scene, and gain a more complete vision of the buildings and public plazas, all rendered with an accurately drawn perspective.

THE SUBJECT

Urban Sketching: The Necessary Materia

Nowadays, nearly everyone has a digital camera. However, there are still many artists who prefer a drawing to capture and express urban subject matter, because of this medium's vitality and immediacy. In fact, there are many groups and associations that organize thematic itineraries that direct their members through a city so they can enjoy a session of urban sketching.

Sketchbooks allow you to capture the urban landscape in a quick and natural manner. Preferably, they should be small and easy to carry. They are made with drawing paper, watercolor paper, and even paper prepared for oil painting.

In addition to a sketchbook, it is a good idea to always have a digital camera at hand to instantly take photos that can later be used for working at home.

The Sketchbook

This is an important tool for working outdoors. It is the canvas on which the artist interested in urban themes makes notes and sketches the aspects that most catch his or her attention. It is the place to lay out perspective, gaining confidence in projecting the geometry of the buildings and learning to express them in the loosest and most intuitive ways, while interpreting what you see with just a few lines.

The Model in a Few Lines

A sketch is the result of immediate observation, a jousting field where the artist constantly challenges himself and attempts to make stronger and more confident drawings. Artistic perspective is not too mathematical; it is more intuitive, so there is no need to carry rulers, squares, and triangles. You must learn to draw straight lines freehand. You should draw with a pencil or pen, and later complete the sketch with washes or paint in the comfort of your home, trusting in your memory of the image or using photographs that you may have taken.

A pencil or ballpoint pen is enough to get started in urban sketching. The first exercises should be aimed at understanding the structures of buildings and the angles of their sides.

A ballpoint pen drawing made in front of the actual model can later be finished at home or in the studio by adding watercolor washes that will make it more attractive.

The **First Lines**

In the urban landscape, the composition is not defined by natural elements that are more or less distant, or by geographic landmarks, but by structures and solid geometric constructions. The buildings, streets, and plazas are what give form to the urban landscape. The precision of the architecture and the illusion of the perspective require the artist to be very precise when laying out the drawing of the model.

The starting point is a very simple drawing made with charcoal and just a few straight lines that indicate the size and location of the urban space.

Line drawings are a great help when representing cities, especially when you need to define the lines, edges, and outlines of the buildings.

The First Lines

The first thing an artist must keep in mind when laying out a composition is the value of the structural lines that, generally, coincide with the outlines of the buildings or the perspective of the streets. Therefore, in an urban landscape, it is important to begin with a geometric drawing to indicate, at least roughly, the layout, orientation, and extension of the buildings. The lines should be long, quick, and direct the viewer's eye by using the diagonal lines of the composition, which enliven the work and break up the dominance of the perpendicular lines of the buildings.

Shadows and Masses of Color

Although the basis of every layout you draw will be geometric, the painting will be based on the synthesis of areas of color of equal intensity or tone. In this way, the planes of the façades of the buildings will join with each other to form streets, and together create large areas of light and shadow. Therefore, when painting, do not depend on lines, but areas of graded color that suggest surfaces and space. Graded color on a façade or on the asphalt of a street is important for expressing depth.

After the forms are indicated with lines, they can be reinforced by adding shadows or large areas of color, as in this oil sketch.

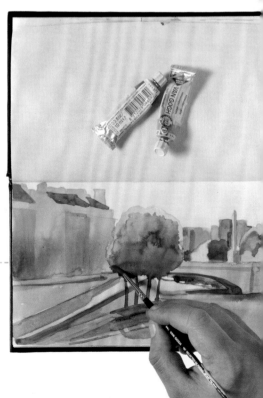

Watercolorists prefer to start their paintings with areas of color that suggest changes in surface or a succession of shapes. This very simple approach creates a nicely synthesized view of the subject.

Shadows Emphasize the Architecture

Once the main lines have been laid out and the construction resolved, you should distribute the most important areas of shadow. In an urban landscape, it is impossible to disassociate the shadows from the buildings, because it is the contrasting light that produces the changes in planes and that helps to explain how the different elements that make up the model overlap each other.

The buildings located in the foreground always have darker values and more contrasting shadows than those in the background.

The areas of shadow are an excellent addition to a line drawing. They help add depth and indicate where the buildings overlap.

A foreground bathed in a deep contrasting shadow throws light on the back of the alley. You must learn to make use of these contrasts.

Strengthening the Lines

Dark tones have a great visual weight that can be used to balance the grounds of your drawing. If used well, they can emphasize the mass and the outlines of the buildings, and allow you to create very strong lines that direct the viewer's eye toward a specific point. Some aspects to consider: the lines on houses in the foreground will have a darker and stronger value than the outlines of houses that are farther away; and, when you create large areas of light or shadow in an urban landscape, it is important to create variations in tone so they will not look too flat.

Different Times of Day

When you study the light in a photograph, you can be sure that it is not going to change, and therefore you will have enough time to study the projected shadows and give them the necessary intensity in a patient and unhurried manner. But, when you are working outdoors, the sunlight changes quickly, and this requires you to work quickly and simplify your work. This means that a single street or urban scene can be used as a model as many times as the light changes in a day.

When approaching an urban landscape, you must take time to study the movement of the light on the buildings at different times of the day. In the early morning, the colors are blue tones and there is little contrast among them.

During the afternoon, the lighting conditions change; and, although you are looking at the same model, it looks completely different. The light has turned orange, and the contrasts between the light and shadows are stronger.

THE SUBJECT

Constructing with **Color**

Until now, you have seen how line and shadow define the urban landscape. You still need to study the use of color in the scene and the basic role it plays in highlighting the chromatic aspects of the façades (the reddish intensity of the roof tiles), especially when you are looking at traditional picturesque architecture.

Picturesque villages offer wonderful possibilities for the colorist painter. The lively painted façades brighten every corner.

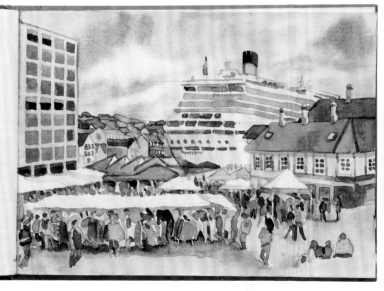

In large cities, the artist can find color in street markets, where people congregate to form an amalgam of small strokes of color.

The Picturesque Factor

Many think that a view of an urban area is made up of a range of gray tones, but this is not always the case. There are a great number of picturesque villages with façades decorated with bright colors that create interesting chromatic effects for the artist. You only have to choose the right place, and, if necessary, strengthen the colors a bit more on your palette. It is a matter of working with pure colors taken directly from the tube with very little mixing, so that you can create strong contrasts.

Chromatic gradients will strengthen the effects of distance by using warm tones on the buildings in the foreground and blues and light colors on those in the distance. In this sketch, the colors have been exaggerated to make this easier to see.

The Gradients of a Grand City

In cities, the color tendencies are different, becoming more homogenous and gray. You can resort to a chromatic gradient to create depth, avoiding the monotonous colors of the buildings. You must encourage warm tendencies (yellow and orange touches) in the nearby buildings and apply blue and lighter shades in the outlines of the buildings that are farther away. This is useful, especially in urban scenes with a lot of depth.

In this composition, the bridge was painted with reds on a background of blue and green, using oil pastels and watercolor washes.

Vito d'Ancona
(1825–1884)

D'Ancona achieved great success with his simple, direct paintings, where flat areas of color with few details predominate.

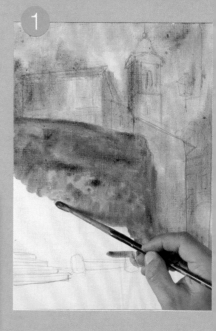

Portico *(1861)*

This urban scene depicts a portico in the foreground bathed in shadow while late afternoon light reflects off the walls in the narrow street. This is a color sketch made by d'Ancona on-site. It is constructed with areas of more or less uniform color, in oils, and shows few details and a frugal color range, and sticks to a clear and simple visual language.

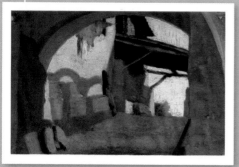

1. Make a simple pencil drawing, then cover it with a preliminary layer of diluted oils, a mixture of blues and violets in the sky, and sienna and ochre in the lower part of the painting.

2. Leave the foreground in shadow, just like d'Ancona's painting, using oil glazes, while the façades of the buildings are covered with opaque oil, thick and not-too-well mixed on the palette.

3. The colors of the façades are flat and uniform, painted with a range of earth tones. Draw the details of the bell tower over the fresh paint and scratch in the details of a house.

4. Paint the vegetation on top of the wall with chrome green, sap green, and Payne's gray, using short gestural brushstrokes to make it look convincing.

This Italian painter was born in Pesaro and trained in Florence, where he was in contact with the most academic painters in the city. In 1844, he was admitted to the Accademia di Belle Arti, but a few years later he abandoned his classicist painting style to pursue Realism, which was inspired by Courbet. d'Ancona had many followers in Florence who frequented the Café Michelangiolo, and they soon became known as the *Macchiaioli*. This is when d'Ancona stopped working in a studio and became interested in painting outside, in front of the real model, to directly capture the light and its effects.

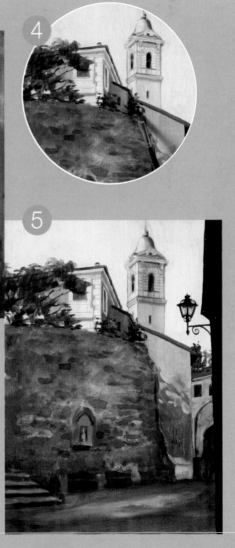

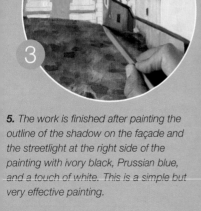

5. The work is finished after painting the outline of the shadow on the façade and the streetlight at the right side of the painting with ivory black, Prussian blue, and a touch of white. This is a simple but very effective painting.

A Building with
Just a Few
Lines

In some ways, it is easier to capture the essential character of an urban landscape than that of a natural landscape, because the former has a very well defined structure consisting of straight lines and solid buildings, while the latter is amorphous and changing.

Begin drawing the architecture in pencil, first with a light line while simplifying some of the elements.

The perspective should be drawn freehand. It is not important if it is completely correct, as long as it looks like the model. The point is to practice the structures.

With a little practice, it will soon be easier to attempt more ambitious drawings—much more complex historic buildings, for example. However, you must continue to synthesize and control the line.

The planes of the buildings become meaningful when they relate to each other while maintaining their proportions and the angles of the lines used to draw them. In this section, we will attempt to sketch the structures of different types of buildings, from the most simple to the most complex, indicating their characteristic forms with well placed lines. First, it is important to carefully plan not just the structures of the buildings, but also their proportions in relation to the rest of the architectural grouping.

The ballpoint pen is a very handy drawing tool, very useful for making a few quick and accurate lines that can later be wetted with a brush.

Its clear and intense line is good for quick and dynamic strokes that are very appropriate for depicting contemporary architecture.

Controlling the line and the angle of perspective of the façades is important in creating a true view of the model. It is a good idea to practice all architectural styles.

Interesting **Parks**

An urban landscape does not have to be composed simply of buildings or streets full of people. It is also possible to paint parks, green islands in the heart of cities. They are spaces full of vegetation, where the urban becomes a backdrop, barely a silhouette that surrounds the calm and natural environment of the park.

Parks are a mixture of city and nature, normally with a barrier of vegetation in the foreground and the distant contrast of the buildings that looks like a theatrical backdrop.

The urban elements can be resolved with lines that highlight their formal characteristics, while the vegetation can be constructed using strokes of color, sometimes in a very loose manner.

The Park as an Excuse

Including a tree-filled area in the representation of a city becomes an important narrative element for various reasons. In the first place, because it helps enrich the chromatic aspect of the work by including ranges of the color green, which is very scarce in urban spaces. And, secondly, because this type of scenery produces an interesting formal contrast, placing rounded forms with indistinct outlines alongside the flat, hard-edged structures of the buildings. In addition, the park can be a subject that is much calmer than the bustling streets.

Some Advice for Painting Parks

A park is not a natural wild space, but a humanized territory. Therefore, it is important to reinforce the urban details, whether including buildings as a backdrop, painting people strolling through the area, or incorporating architectural elements in the painting, like traffic circles and monuments or street furniture, like light posts, benches, and fountains.

Some urban elements in the parks, because of their unique architecture, become interesting focal points of the painting.

The vegetation is depicted with dark greens, while the buildings in the background are sketched quite loosely in reddish tones. The details on the façades are not given any importance at all.

Panoramas

When a panoramic image is made of a city, it is notable for the wide visual horizon it covers. It is characterized by its very wide format: a plaza, an open space, a view from a high angle. This final option can be very interesting, because it allows you to capture, from an elevated viewpoint, a horizon that is a good deal wider than that which is normally seen or can be covered on foot in the street.

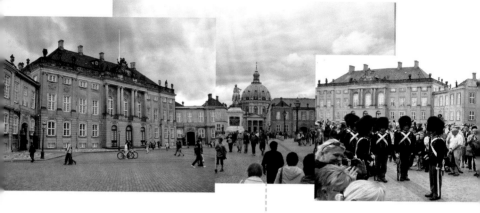

Sometimes, elements of the drawing look curved or deformed. *You should not view this as a defect, because the deformation of the angle is a photographic approach that can be applied to drawing.*

You can stitch together several photographs. *When joined, they create a panorama, a wide format that allows you to represent the buildings on a very large plaza.*

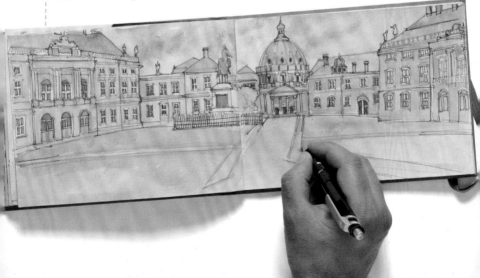

Stitching

A panoramic drawing usually includes many details and requires dedicating a long period of time to its creation; therefore, some artists depend on stitching photographic images, which are taken with a digital camera that is rotated a certain amount after each shot. Then, the photos are joined to construct a complete view. This is a collage technique that distorts the perspective, especially if you use wide-angle lenses; but far from being a problem, the solution is to apply the same distortion to the drawing. This way, the representation becomes unique and more expressive.

The Gradient of Distance

The tonal values seen in an open space that is very deep can vary greatly if you compare the foreground with the farther grounds. The nearest ones always feature livelier colors; and, as they get farther away, everything becomes gray, bluish, and whiter. The outlines of the closest buildings to the viewer are lighter, linear, and clear, and they lose definition and intensity as they recede into the landscape. Linear perspective can also be applied to represent a panorama. Simply use a grid constructed with two vanishing points that will help you neatly lay out the buildings.

An elevated position allows you to see that, in the distance, the buildings become simpler and the details on the façades become blurred. The opposite happens in the foreground, where the edges of the structures are much clearer.

When representing a scene in a city from an elevated point of view, you can make use of a grid drawn with diagonal lines that converge on two vanishing points on each side of the picture (1). Then, it is a matter of making the building coincide, more or less, with the fictitious diagonals. The result looks harmonious and ordered (2).

An Urban Sketch
with Watercolors

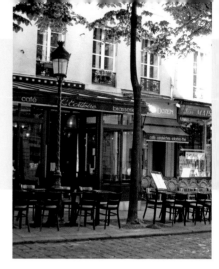

*A quiet and shady corner at a Parisian
sidewalk cafe.*

1. *Make the drawing with a graphite
pencil on a page of your sketchbook.
Make light and barely perceptible lines
to block in the main elements of the
composition.*

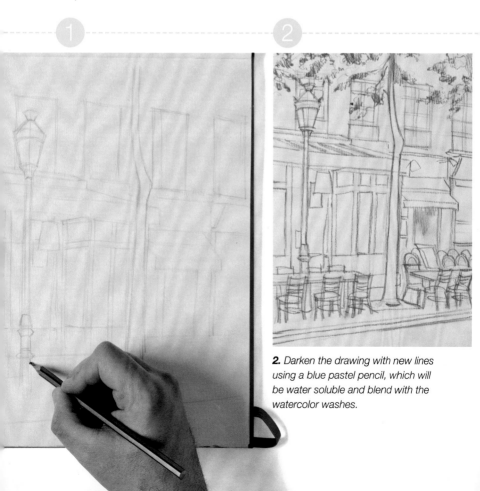

2. *Darken the drawing with new lines
using a blue pastel pencil, which will
be water soluble and blend with the
watercolor washes.*

The need to learn inspires continuous practice sketches, drawings, and on-site work as a quick way of getting a likeness of the model and achieving good results in a short amount of time, usually combining drawing techniques with watercolor washes. In these cases, the watercolor is used to separate the planes in the drawing, to create variety and depth, and to add greater realism to the urban scene. In the following exercise, you will mix pastels, watercolors, and gouache to represent a quiet corner of a Parisian sidewalk cafe, which is a good example of what we are talking about.

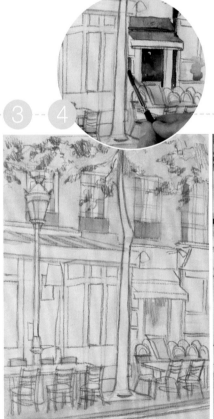

4. After the previous washes have completely dried, you can paint the openings, doors, and windows with very dark Payne's gray mixed with a bit of indigo blue. At the same time, you can add the first reddish washes on the chairs and awnings.

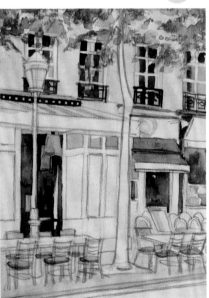

3. First work on the white colors on the façade with a very light wash of diluted sienna. When this wash enters in contact with the pastel lines it will become slightly bluish.

5. Add a few light and short brushstrokes of very diluted sap green to represent the leaves of the trees. This color will take on some blue tones when it blends with the lines drawn with the pastel pencil.

6. Before painting the awnings over the bars, draw the letters with yellow and white wax crayons. The wax lines will repel the washes and leave the white letters that you have drawn.

8. The frames of the bay window of the bar can be painted with an unequal mixture of emerald green and sap green combined with Payne's gray. In the upper part, apply strokes of white gouache to describe the white light that can be seen through the leaves of the trees.

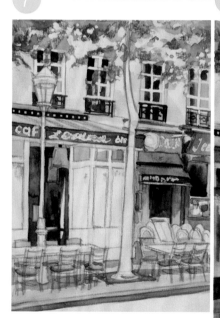

7. When you apply the reddish washes, the letters will be white like the paper. Other letters and the lights of the businesses can be drawn with yellow wax crayon. Add some greens to the façades of the businesses and on the leaves of the trees.

9. The glass panes are painted with a mixture of green, gray, and ochre (very diluted) applied directly on wet. The tree trunk and the interior of the business can be painted with a mixture of burnt umber and a little green or scarlet and blue depending on the case.

10. All that is left to do is to add the final details to the chairs with washes of burnt umber. The washes should not completely cover the blue lines, but complement them. Use ivory black for the lamppost on the left, leaving the reflections of light white.

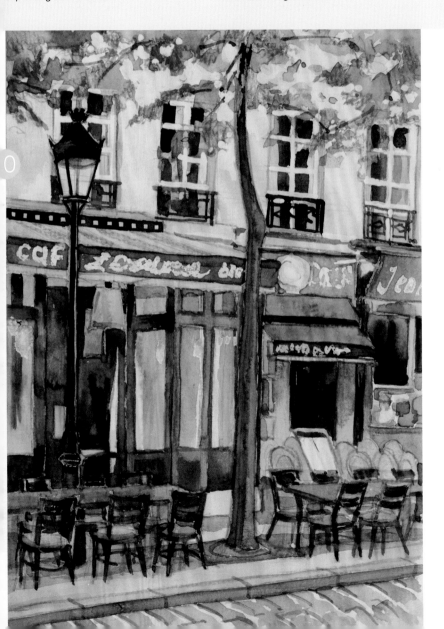

Balconies, **Windows, and Lampposts**

Urban landscapes can have very attractive subjects for painting in corners and small interesting details. Here, the importance depends on a fragment, a foreground or an isolated element that can seem to be full of details when the shadows and the textures that define it are accentuated.

The façades of buildings contain surfaces, textures, and elements that are interesting enough to be the focus of a work, like this group of windows.

Artists are usually attracted to architectural details, especially those that stand out because of their beauty and originality.

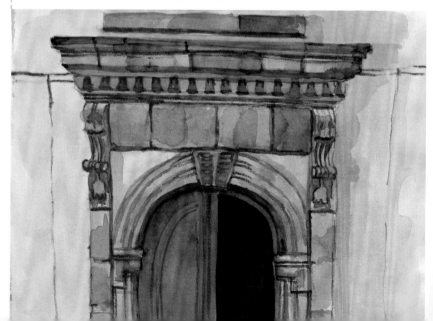

Interest in the Texture

Surprisingly, architectural details that seem to be just fragments on the building can become studies of the surface texture, ornaments, and details. These subjects, which also form a large part of an urban landscape, become small decontextualized scenes where the contrasting light, highlights, and the textures of the materials become very important—for example, the metallic reflections of a lantern, the reflections on a windowpane, or the texture of a crumbling wall.

Some artists are especially interested in the trivial details of urban decor—an antique lamppost, for example, whose filigree can be meticulously rendered.

Urban scenes not only consist of the large open spaces in cities, but they can also reflect the intimacy of a small patio or a hidden garden full of details.

Isolated Elements

For artists who are interested in the details, the forms contained in the general structures of buildings offer a large amount of very interesting subject matter: an alley, a shop window, a portico, an old lamppost, even a balcony. These can be as interesting to draw or paint as the buildings they are found on, with the advantage that, because they are so near to the artist, there is almost no need to apply perspective to them.

Buildings
and Architecture

The great challenge in representing an urban landscape is the architecture, the three dimensional representation of the geometric forms. To successfully do this, it is necessary to have a solid understanding of perspective, so that you can make convincing drawings and paintings. Laying out the perspective of a model is usually done by drawing very carefully structured lines with charcoal or graphite that indicate the forms while completely ignoring the details. This is done to determine the locations of the buildings and the angles of the walls, the roofs, the streets, and even the shadows projected by the buildings. The perspective and the proportions must be correct. Then, after the main structure has been laid out, the details may be added—doors, windows, fountains, lampposts, and urban furniture in general.

THE SUBJECT

Elementary **Perspective**

For beginning artists, the greatest challenge is to simulate the sense of depth created by the view and the shrinking shapes of buildings in the distance. This can be achieved with the help of perspective, which outlines the space in a geometric manner by using the concepts of projection and section.

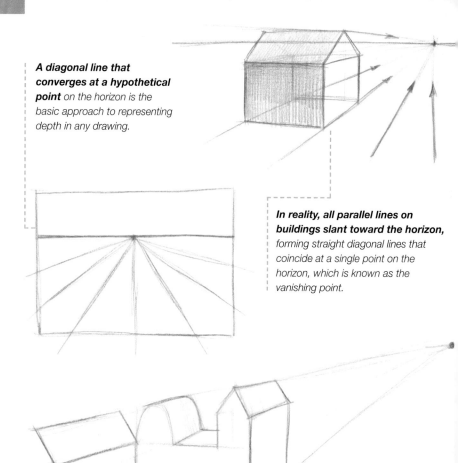

A diagonal line that converges at a hypothetical point on the horizon is the basic approach to representing depth in any drawing.

In reality, all parallel lines on buildings slant toward the horizon, forming straight diagonal lines that coincide at a single point on the horizon, which is known as the vanishing point.

After you understand the basic mechanisms of perspective, you can do some very simple exercises projecting isolated urban structures that are not very complicated.

Trusting the Lines of Perspective

If an inexperienced artist decides to ignore the theory and only trust his or her eyes, the resulting images often will not fit together well. When approaching an urban landscape, it is important to keep in mind the basic concept of perspective, which is based on projecting lines that direct the buildings toward a vanishing point. Once the lines of perspective are established, it is possible to create an accurate sketch. The horizon line will be located on the paper.

The horizon line is often covered by the buildings and urban furniture—in this case, by traffic lights—but this does not mean that it does not exist. Sketch it even though it will be hidden when you represent the depth of the street.

The Basic Perspective Grid

Before starting the drawing, make a straight horizontal line to indicate the horizon, and on it place a vanishing point where all the lines of the buildings that you are going to draw will converge. The lines located below the horizon line will be the bases of the buildings, representing the plane of the ground, while the lines that are above will be the peaks, rooftops, and cornices. The vertical planes are all perpendicular to the horizon line and parallel to each other. Once all the lines are projected, you can sketch the geometric forms that will indicate the shape of each building.

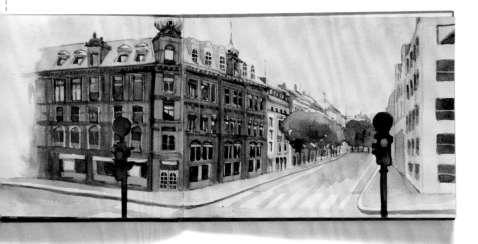

Guillaume Vogels

(1836–1896)

A graduate of the Royal Academy of Fine Arts in Brussels, Vogels was able to combine his career as an artist with that of a decorator, which was his actual profession. He

Elsene, rainy morning *(ca. 1880).* *Vogels' cityscapes are characterized by their rich palette of blue-grays, by the energy of the full-bodied brushstrokes, by the spontaneity of the applications of color that blur the façades and give them a certain amount of ambiguity, and by the emotion that adds to the expressiveness of the scene. Leaden environments full of blue tones are typical of his paintings of stormy, changing weather. The buildings are barely silhouetted and are bathed in a light fog that indicates a rainy scene, as do the umbrellas of the passersby.*

Guillaume Vogels became the greatest illustrator of the Nordic climate, with a predilection for gray and rainy days.

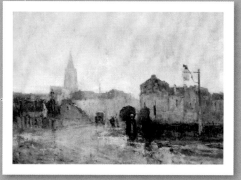

1. *To paint a cityscape inspired by Vogels, start with the sky, creating a gradation that goes from beige near the horizon to very light Prussian blue at the top.*

2. *Using both brush and palette knife, sketch the forms of the buildings very simply: use compact strokes that mix cyan blue, Prussian blue, titanium white, and dabs of ochre and burnt sienna to gray them.*

began as a Realist painter, but soon turned toward more impressionistic representations, characterized by short, overlaid brushstrokes that blurred the urban scenery with a range of changing colors, depending on the atmospheric conditions and weather of Northern Europe.

Beginning in 1879, he enjoyed great friendships with James Ensor and Jean Toorop, who were also artists. From 1884, he participated in exhibitions with the Group of 20 along with Cézanne, Monet, Renoir, Gauguin, and Van Gogh, all of whom influenced him.

3. Using a brush and somewhat diluted paint, cover the asphalt on the street using the same range of colors as on the buildings. Then, add some linear details to the architecture with darker tones.

4. While the layer of paint is still wet, scratch with the blade of a spatula to represent the buttresses of the church and other linear marks.

5. Use a finer brush to add the final details: the openings in the façades in the background using grayed Prussian blue, the passersby on the right with blues and sienna, and the lines of the asphalt brushed on with titanium white mixed with linseed oil.

Buildings **Are Boxes**

If it is sometimes difficult for the beginner to apply the laws of perspective, it might be easier to imagine the cityscape as being composed of a pile of boxes—prismatic shapes—as this will better help one to understand the structure of the model. It helps to have a basic understanding of how to represent geometric shapes in perspective to project buildings and streets accurately.

Using the basic principles of perspective, create the basic structure of buildings by stylizing them with rectangular geometric forms.

Buildings with complex structures can be indicated by combining or stacking several simple geometric forms.

Once you understand this approach, you can put it into practice. In this case, the corner of a block of buildings is assembled of different geometric forms whose edges converge at the horizon.

Superimposed Rectangular Forms

Knowing how to correctly use drawing techniques will not help you if the structure that the drawing is based on is not properly constructed. Therefore, the sketch that is made in the first steps has to include a synthesis of the forms of the landscape. This can be done by superimposing or layering rectangular forms, which represent each of the buildings that you wish to draw. These rectangular forms will be overlapped or overlaid on each other. This way, the architecture can be laid out in a few minutes, in a very simple manner.

Some Considerations

This way of laying out the architecture, as simple as it is, cannot forgo the use of perspective, because the rectangular shapes must be indicated with lines of perspective that depend on your point of view. In addition, it is essential that in representing the superimposed planes or geometric shapes, the size of the distant buildings must decrease in relation to the nearer ones, even though in reality both may be of the same size. Initially, they can be drawn as if they were transparent; but, once you create the basic layout, it is a good idea to erase the lines that you are not going to use to avoid confusion.

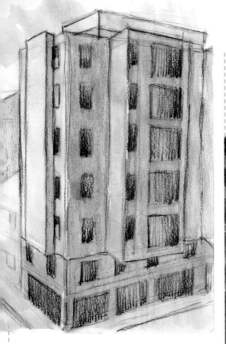

The well-defined forms of buildings and rooftops give you the opportunity to construct the architecture by assembling rectangular geometric shapes to achieve very attractive results.

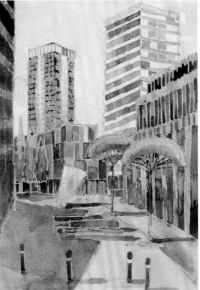

All structures can be synthesized with simple geometric shapes.
Then, you can finish drawing the doors, windows, and balconies, and apply a preliminary shading to emphasize their volume.

Urban Drawing with **Collage**

The following drawing is of a group of unique façades, very picturesque and with very different architectures.

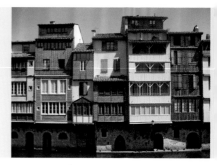

1. First you must gather different kinds of paper, with varied colors and textures. Cut them out and attach them to the paper with white glue, using the buildings in the photograph as a model.

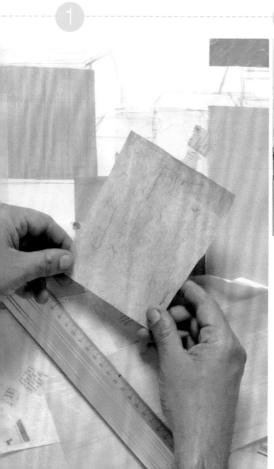

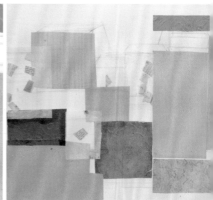

2. The papers form a varied and balanced geometric structure that is going to make a very interesting drawing. The cutouts do not have to match the sizes of the façades or the proportions of the buildings.

To create an original composition that transmits a feeling of rhythm and architectural variety, you should work with color pencils on a collage base—that is, incorporating small colored paper cutouts that will reinforce the structural aspect of the architecture, and at the same time help vary the colors of the drawing. The entire drawing will be complemented with highlights created with a thick layer of white gouache. The result will be a drawing that is not very conventional, but very attractive and dynamic.

3. When the glue on the collage is completely dry, you can begin sketching with a graphite pencil. This will allow you to erase if necessary. Use the sketch to lay out where each building will go.

4. Using the graphite lines as the only template, draw the elements that appear on each façade with two blue pencils of different tones. Color the sky with light geometric gradations and deliberately omit some of the elements from the buildings.

5. The shapes of the windows and the balconies can be left somewhat unfinished— and, in some cases, even suggested. Then, add projected shadows in triangular shapes. The work displays a clearly geometric approach.

6. The front view of the façades does not make use of perspective; the feeling of depth is achieved by outlining the walls between the buildings, slanting the lines to create a feeling of depth.

7. Each building is treated as a series of geometric forms that are emphasized by shading, creating gradations using the two blue tones of the pencils. These shapes reinforce the geometric structure of the grouping.

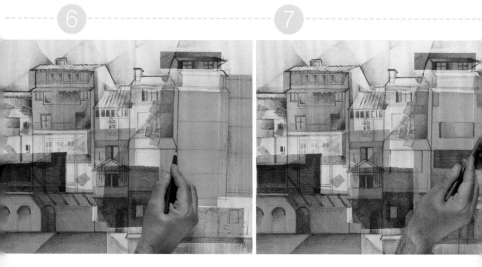

ARCHITECTURAL RHYTHM AND VARIETY

8. *Using a brush, apply a final layer. This time use opaque white gouache in order to construct the wood frames in the galleries.*

9. *The river requires very little attention, while the doors on the lower part of the walls can be colored with darker shadows, by just applying more pressure with the pencils on the support. The final representation of the façades is attractive, dynamic, and not at all conventional.*

A Receding **Street**

In drawings and paintings of streets that disappear in the distance, the feeling of depth can be achieved using graphic techniques, linear structures, and a scheme of diagonal lines that converge on a single point of view. This diagram is essential, not only for representing the depth of the street, but also to indicate how the sizes of the buildings decrease in the distance.

The next step is to adjust the perspective to your needs. *In this case, the lines of perspective help define the structure of the building in the foreground and the placement of the trees.*

The lines of perspective converge on a single point. *This helps with the preliminary layout that represents a street in perspective.*

The linear perspective helps add depth to the scene *and creates a wide space. When it is painted, the initial drawing will completely disappear.*

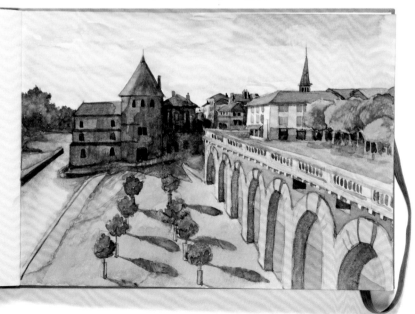

A Single Point

The façades of the buildings and the streets look smaller as they move away from the viewer and closer to the horizon. This effect is easy to create using a one-point perspective, which is a fictitious vanishing point located on the horizon line where all of the diagonal lines in the drawing converge. The diagonals that are projected above the horizon line determine the height of the buildings and those that are drawn below determine their base.

The diagram must be used for all cases. Here, the model requires a central vanishing point with the lines of perspective arrayed in the shape of a windmill.

The correct angle of the street, of the buildings, and of the doors and windows is what communicates the feeling of depth.

Representing a Street

A classic example of a one-point perspective is a drawing of a street, whether long or short, that disappears in the distance. The lines that indicate the asphalt and the sidewalks are diagonal, and they converge as they recede, until they meet on the horizon. You must keep in mind that the width of the façades of the buildings and the spaces between the trees and the lampposts also get smaller as they move away from the viewer. In a rural scene, the sketch must be adapted to the winding roads.

Two-point Perspective from a Corner

In densely populated modern cities, the nearness of the buildings to each other often makes it difficult to get back far enough to represent a group of façades using just a single vanishing point. You must use a perspective with two vanishing points, risking that the final representation may seem forced and slightly distorted.

To represent a building using a two-point perspective start with a straight line to define the corner, and then draw diagonal lines that converge at two vanishing points located at each side.

The best way to practice is to sketch very simple structures. Each façade should have lines of perspective that recede in opposite directions.

Finish the small house and integrate it into the surroundings. The same lines of perspective determine the angle of the roof tiles and the wood siding.

Two Vanishing Points

To draw a building with two vanishing points, begin with a straight perpendicular line to define a corner. Project two diagonal lines from each side of the straight vertical line to two vanishing points located on each side of the vertical to the horizon line. These will determine the height of the building. It is important for these two points to be far apart; otherwise, the buildings will be excessively distorted.

Reversing the Direction of the Diagonal Lines

With two vanishing points, each building and each side of the street will seem to have its own perspective. Each vanishing point defines the perspective of the façades on their corresponding sides without interfering with the other. This system is useful for representing nearby buildings, drawing two streets at once, and rendering plazas and open spaces. By reversing the direction of the diagonal lines, extending them past the perpendicular vertical line, the corner will become the farthest point from the foreground.

Some models may seem complicated; however, the diagram should always be the same. You only have to vary the height of the buildings.

Two-point perspective is essential for representing buildings that are near the viewer and for organizing space in an understandable manner.

Drawing with
Shadows

The urban landscape is not only composed of lines of perspective that indicate the structure of the buildings, but also of planes that can be seen because of shading. In fact, it is often difficult to separate the shadows from the buildings. The dark tones have great importance in

Using a violet wash, make a sketch of an urban model, trying to capture only the areas with the most contrast.

Do not try to make precise drawings; just indicate the main areas of shadow. The contrast with the white of the paper will create a recognizable scene.

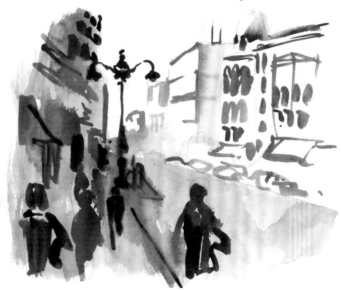

The background can be rendered with diluted paint, barely adding any details, while the shadows of the figures in the foreground should be darker, because they are silhouetted by the light behind

the balance of the composition and in understanding volume; a well-placed shadow will give a building, a wall, or a façade substance, while at the same time directing the viewer's eye, directing his or her attention toward a specific point. Here are some examples done in watercolor.

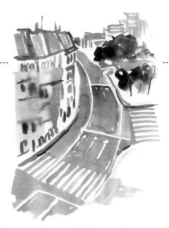

When painting façades, you must develop the ability to combine wide brushstrokes with finer linear ones. The synthesis of the two is the key to these drawings.

These exercises will help you free yourself from the slavery of the line and understand how shadows and variations in tone are partly responsible for the creation of space.

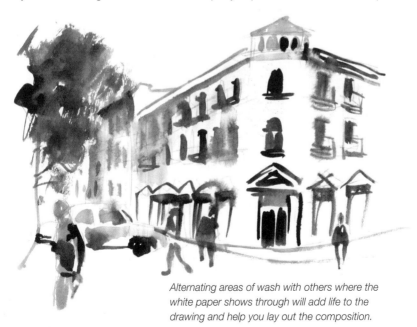

Alternating areas of wash with others where the white paper shows through will add life to the drawing and help you lay out the composition.

A City Park in Pastels

The avenue in this park has trees that are carefully pruned and laid out in an orderly and balanced manner.

"DOMESTICATED" NATURAL SPACES

① ②

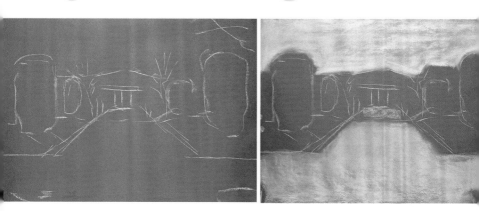

1. The preliminary drawing is done with a pink pastel. The very simple lines should organize the composition from the first moment. Above all, you must pay attention to the lines of perspective.

2. Paint the largest areas, the sky and the sand on the road. First, apply shading with pink and blue, and then rub them with your fingertips.

3. Use a stick of charcoal to shade the bushes along each side of the avenue. The façade of the classical building blurred by the distance should be drawn with charcoal and pink pastel.

4. Blending the charcoal and the pastel will create a middle gray tone to cover the façade of the building. Paint the areas of grass with pale green, using the side of the pastel stick.

Urban parks are "domesticated" natural spaces that coexist in harmony with the surrounding buildings. The work that you will create on the following pages is a good example of this. It is an avenue in a park that leads toward a façade of a classical-style building in the background. Use dark green paper to emphasize the contrasts of light; it is an ideal base color for highlighting the impact of direct sunlight with dry pastels.

5. Rub the surrounding vegetation to blend it with the gray buildings in the background. The green of the grass will look denser after blending it with your hand, which will cause the pigment to penetrate the grain of the paper.

6. Once the space is resolved, emphasize the main areas of light, with light green lines that highlight the outlines of the vegetation.

7. Add the projected shadows on the ground by drawing lines with a charcoal stick. You must apply pressure so the charcoal will adhere well to the pastel.

8. The dark charcoal lines can be completely eliminated, by blending them with your fingers to create a more convincing shadow that is more in line with the general style of the drawing.

9. The drawing of lines is left for last. Use the sharpened point of a gray pastel to draw the thin, bare tree branches in the center and upper part of the composition.

10. The treatment of the color has been somewhat stylized, but that does not keep the work from exhibiting a strong feeling of space, enlivened by the contrasts of the vegetation and the strong play of light caused by the direct sunlight.

Camille Pissarro
(1830–1903)

Along with Monet and Sisley, Pissarro is considered a pure Impressionist and one of the pillars of the movement.

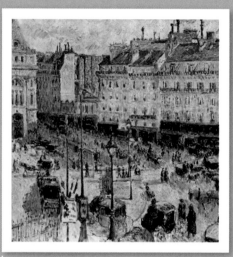

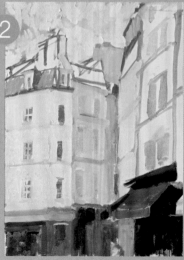

Place du Havre *(1893)*
After a period of experimenting with the Pointillism promoted by Georges Seurat, Pissarro returned to his short overlaid brushstrokes, which he used during the early days of Impressionism, and to his series of urban scenes. One example of this stage of his career is this view of the Place du Havre, which he painted many times while barely changing the point of view. The lively divided brushstrokes in this work enliven the representation. The façades are illuminated with twinkling lights, and you can almost see the movement of the trains, the carriages, and the crowds, all represented in a very vigorous manner.

Pissarro, who is considered to be one of the founders of Impressionism, painted rural life as well as urban scenes from the French capital, which consist mainly of boulevards, squares, and wide avenues full of people and traffic. In his works, painted with short overlaid brushstrokes, the artist makes it clear that his main interests are the effects of light and atmosphere; because of this, he was as highly regarded as Monet. However, in 1895, an eye illness that would eventually leave him completely blind obliged him to limit his paintings to urban scenes, and from that time he painted views of Paris from a window in his house.

1. *We have chosen a group of Parisian buildings for this oil painting. The drawing is done directly with a brush charged with cobalt blue. Then, the façades and awnings can be painted with whitened colors.*

2. *You should cover the white of the support under a first thick layer of paint, applied flat on the buildings and thicker in the sky, using juxtaposed brushstrokes applied in different directions.*

3. *With gray and brown tones, add the shadows that add depth to the shop windows and the windows in the façades.*

4. *On these layers of fresh paint, practice Pissarro's Impressionist brushwork. This consists of applying short strokes that create the sensation that the atmosphere is agitated or vibrating.*

5. *Use quick brushstrokes without worrying about the drawing. Overlaying small strokes creates an architectural grouping that is full of life, with movement and activity.*

Panorama with
Pencil and Wash

The model is a view of a port city from a nearby, elevated viewpoint.

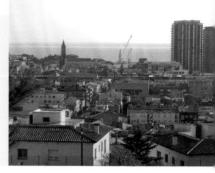

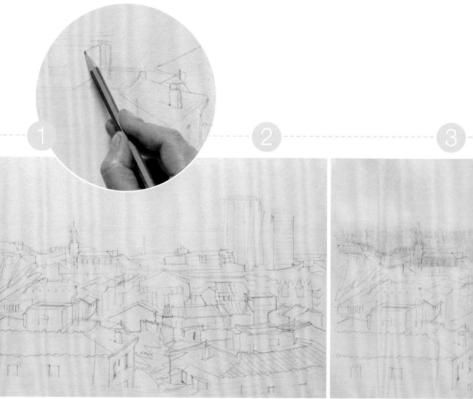

1. The drawing should be done with pencil. First, block in the nearest buildings, which will have a greater amount of detail. It is not necessary to represent the city exactly as it is in reality. You can make some changes.

2. Organize the forms so that they lead the viewer's eye over the entire drawing. To do this, you must distribute the buildings in a zigzag manner, trying to use lines to relate the elements in the foreground to those that are farther away.

Many times we have contemplated the city from a high viewpoint that allows one to see a panoramic view of blocks and even entire neighborhoods.

But, sometimes when the city is spread out several miles in front of us, with a very wide view, it is difficult to locate a focal point to hold our attention and keep us from being bored. This exercise in watercolors alerts us to the dangers of such a panorama, and shows us some tricks that will keep the representation from becoming too monotonous.

4. *Before continuing to dampen the urban grid, make some reserves with a white grease pencil. The lines will repel the wash, preserving the white tone of the paper.*

3. *Use a wide brush to apply a wash on the sky and allow it to dry completely. Then, apply a second blue wash that separates the horizon from the sea, and color the group of buildings.*

5. *Paint the shaded façades with washes of cobalt blue. The applications should be even in the background and alternate with some light areas as you move toward the foreground.*

6. After the layer of blue is completely dry, begin working on the buildings in the background in a very stylized manner, applying strokes of sienna, blue, and orange that blend together to suggest light silhouettes.

7. Color the rooftops with red and orange tones in the middle ground. One of the most important elements of a panorama is to stylize and communicate a feeling of depth using color.

PANORAMAS ARE NOT MONOTONOUS

8. It is important to work on the foreground a little more to keep the painting from becoming too homogenous, boring, and without focal points, by adding a greater variety of colors and some details.

9. The green colors for the vegetation, as well as the small touches of the brush that represent the windows, are left for the end. In both cases, the treatment is sketchy and not very detailed.

10. In the finished painting, you can clearly see that all the buildings are drawn in perspective, which is strengthened by the use of color. We have used a range of blues in the distance, and ochre and earth tones dominate in the foreground.

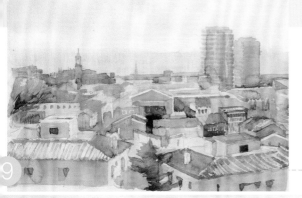

THE SUBJECT

Urban Sketches **in Graphite**

An understanding of perspective and skill at blocking in buildings can be achieved with practice, and the best way is to draw with a graphite pencil. Some artists prefer charcoal, because the impermanence of the lines makes them easy to erase; however, if the blocking in is done with light lines, the graphite allows you to work more easily and loosely and at a smaller size. Ideally, you should have a sketchbook where you can make your drawings directly from the model.

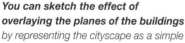

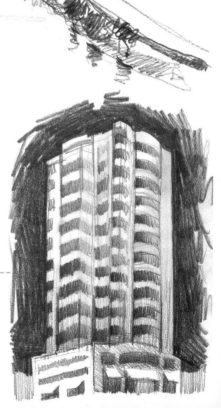

You can sketch the effect of overlaying the planes of the buildings by representing the cityscape as a simple succession of rectangular shapes with different shades of gray.

Make use of the technique called simultaneous contrast. This consists of making a building lighter by covering the background with dark shading that will emphasize its outline.

From Sketch to Pencil Drawing

To start, you should make a geometric sketch of the shapes in perspective; this will be more than enough to understand the space and its limits. The lines of perspective should be vey light, just enough to frame the shapes of the buildings, but not dark enough to be too visible in the final drawing. Draw the façades over the blocked in shapes, darken the outlines, and differentiate the shaded planes from the light ones. An accurate representation of a cityscape depends on the clear differentiation of the planes, which requires strong features in the foreground and lighter edges in the background.

Don't Overdo the Details

When painting a city, you must be aware that it is impossible to represent each one of the thousands of details that appear in the landscape. In addition, an artistic representation does not have to be an exact copy of reality. When it comes to the elements located in the middle ground, it is sufficient to sketch their outlines and darken them with shading.

All pencils sketches are based on developing the lines of perspective that converge on one or another vanishing point. These lines are essential for creating a believable view of the length of a façade.

Representing parks and gardens allows you to avoid the issue of perspective. In these cases, the laying out of the shading and gradations is essential for giving the scene volume and differentiating the planes.

Looking Up: **Skyscrapers**

When you stand at the foot of a skyscraper, you notice that it looks wider at the base than at the top of the building. This is because of the height and, again, because of the effects of perspective on the vertical ascending form. This effect can be rendered by projecting a structure using three vanishing points. As you will see here, it is quite simple.

The upper and lower edges of the skyscraper are drawn using a two-point perspective, while a third point in the sky will cause the size of the building to get smaller as it rises.

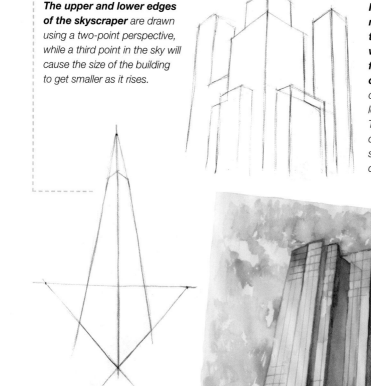

In practice, you must be sure to locate the vanishing points far from each other so that the drawing does not look too distorted. Then, you can combine several simple structures to create a wider view.

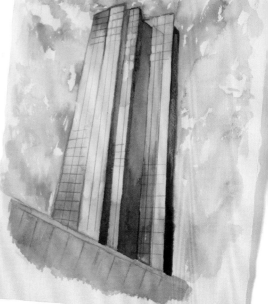

Starting with simple pencil lines, you can color the building and work at making the tones and intensity of the colors change with the height.

Three Vanishing Points

Three vanishing points are needed to draw a tall building. In addition to the lines of perspective that converge on the two points located at each side of the model on the horizon line, a two-point perspective, you must add a third floating in the sky that is responsible for the narrowing of the skyscraper as it rises. To locate the position of the third vanishing point, you only have to extend the lines of the corners of the building until they meet.

Techniques for Synthesizing

Once the structure of the building is laid out, it can be interpreted any way you wish as long as you keep a few basic things in mind. The feeling of the height of the building can be reinforced with graded shadows that emphasize the verticality: darker at the base and lighter at the top. The details should be treated in a somewhat similar manner. For the first floors, the frames and geometric shapes on the façade should be well defined, while the lines should become lighter and weaker as the building gets higher, until they disappear completely.

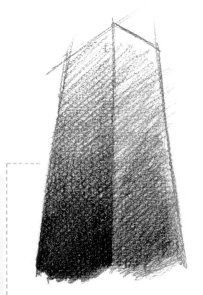

The tonal gradations are shading that emphasizes the effects of the altitude of the building, with darker grays at the base and lighter ones at the top.

The basic principle of lines that converge in the sky can also be applied in the representation of the façade when seen from below. The angles of the lines create a sense of height.

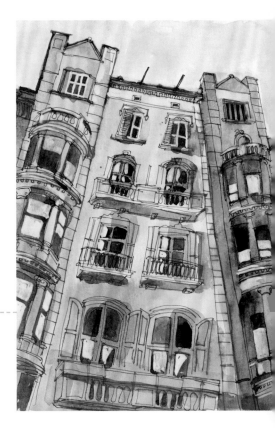

Cityscape with **Diluted Oils**

The largest open spaces of cities, like avenues and plazas, are good subjects for painting with painted strokes of diluted oil paint.

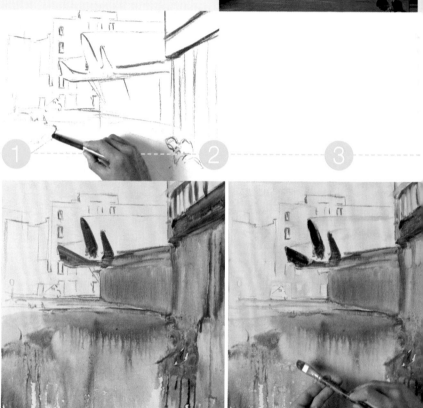

1. This view has very few indications of perspective. Sketch the buildings with lines drawn with a charcoal stick. It should be just a simple sketch without many details.

2. Mix a little cobalt blue with alizarin crimson and add a lot of thinner. The mixture should be applied to the support with a soft hair brush, allowing gravity to make the paint run.

3. Do the same thing at the top of the painting with a mixture of yellow, ochre, and a touch of white. Again, apply very diluted paint so as to create a translucent layer.

Some artists prefer to paint directly with diluted oils to create different variations of gray, changes in light, which they also use to resolve the lack of definition and imperfections of asphalt and sidewalks. With this method, they continue to develop the textures from the beginning, using the translucent base color that incorporates suggestive blends of colors, and even drips, which give the work a more casual and expressive finish.

4. Allow the first applications to dry for a few minutes so that some of the thinner will evaporate. Next, with a mixture of burnt umber, violet, and blue, paint the façade and the silhouetted figures on the right.

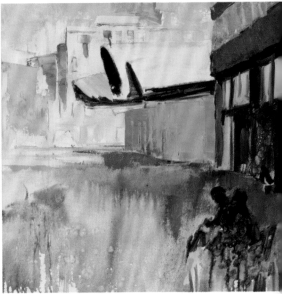

5. Alternate applications of diluted paint with impastos applied with a spatula on the façades in the background. Drag the blade to smooth the thick paint.

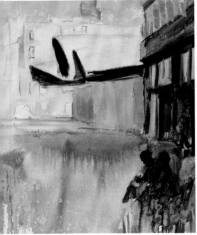

6. Work on the background with the spatula, juxtaposing blues and pinks that will not clash with the rest of the painting. Painting done with a spatula is very stylized and does not support any details.

7. Here, the artist decided to add some pieces of newspaper with white glue, creating a less formal treatment with collage.

8. Use a fine round brush with soft hair to do the finishing line work below the roof of the building. The passersby should be constructed with just two or three very simple lines.

9. The perspective lines of the cobblestones in the street can be indicated with light touches with the edge of a wide spatula.

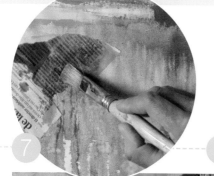

10. Now, you just have to paint the roofs with livelier colors that are lightened a bit with titanium white so they don't clash. In this last phase, the oil should have a thicker consistency.

A FINISH THAT IS "CASUAL" BUT EXPRESSIVE

11. Carefully paint the arches of the building in the background and add new glazes of diluted paint, with dripping, near the figures in the foreground. The diluted paint will be irregular and create a rich range of grays on the cobblestones.

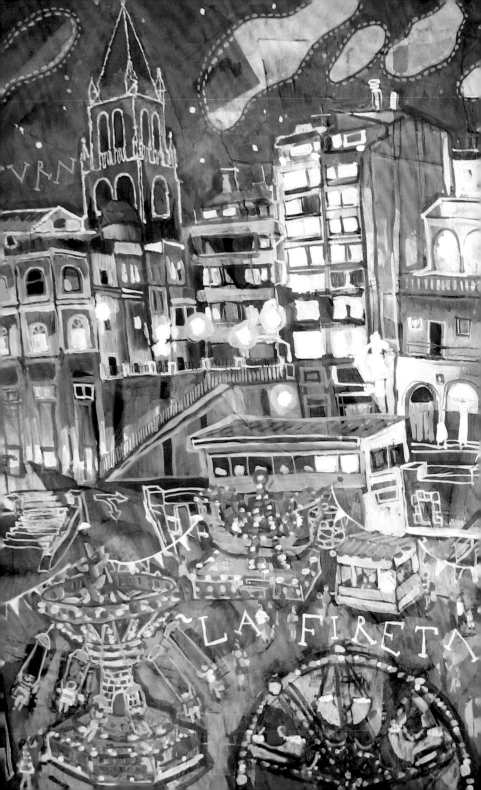

The City in Motion:
Traffic, Atmosphere, and Lights

When painting an urban scene, we become very romantic about the idea of the city, with its alleys, buildings, and small, intimate parks. However, the cityscape can be conceived of as something more than a simple portrait of such things. The traffic, the machines, and the street furniture not only fill the space, but form part of it, breaking up the monotony of the city architecture and giving it some life. The hustle and bustle of the street can transform the most mundane view into a feast for the senses, and you should transmit the action of the place through color, with figures sketched in with brushstrokes and contrasts, and with the play of lights and signs. All this can be combined to create the atmosphere of the place, using a rich attractive color scheme. In this chapter, we include a study of weather conditions that can alter the perception of the urban space, as well as graphic techniques using charcoal to create a more dynamic and expressive representation.

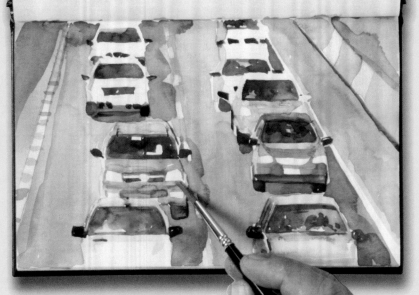

Incorporating the **Figure**

In large cities, scenes of deserted streets feel quiet and lonely. However, by just adding some people, the place becomes animated and full of life. Human figures are not just part of the landscape in this big picture; just the opposite, their presence adds freshness, action, and leads the viewer's eye all over the painting. In addition, they give the painting a certain strength and help reinforce the scale of the buildings.

While a group of nearby figures can be easily distinguished, they become more schematic and lacking in detail as they get farther away.

Unless you are representing an individual building, or panoramic views, people almost always are part of urban scenes. In fact, the movement of humans through the city is one of the attractions in these scenes.

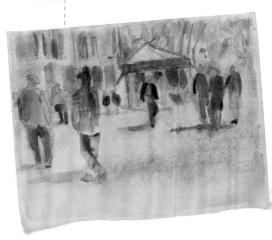

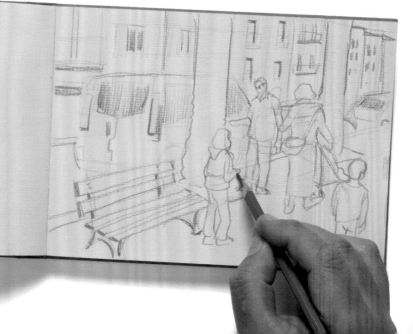

Observe More and Draw Less

The figure is an especially ideal subject to include in an urban landscape, and while it may not be the center of attraction, it is another part that helps the whole work. Passersby are usually represented in natural, day-to-day postures that are not forced or stiff. Observing natural figures is not easy, because they are not usually still, which obliges the artist to be selective and to work quickly. It is best to observe more and draw less—that is, spend a long time watching the model, memorizing forms and gestures, and drawing nearly from memory, elaborating on a sketch.

A Figure in a Few Lines

Start with the figures that are still, whether standing or seated on a bench. The treatment of the anatomy is not important, because the figure can be resolved with just a few strokes and lines, with no details. The goal is not to treat figures individually, but to integrate them into the scene so they form part of the "urban decor."

The initial sketch, which represents posture in a stylized manner, can be completed later if you have time, by adding some shadows and contrasts in the clothing, for example.

Including figures in the streets of a city, among the buildings, introduces a narrative element. When drawing, it is especially important to capture poses accurately so that action that is being carried out can be easily understood.

The figures should be included very simply, with a few brushstrokes and lines. The details are minimal, but the colors, the light and shadow, should concisely model the figures and their clothing.

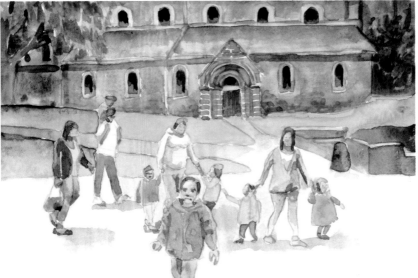

Figure **Sketches**

Cities are made up not only of buildings, plazas, streets, and powerful works of engineering like bridges and highways, but also contain people, a heterogenous group of curious, busy, resting, rich, and poor people, who inhabit and move around cities, forming a lively play of contrasts and forms

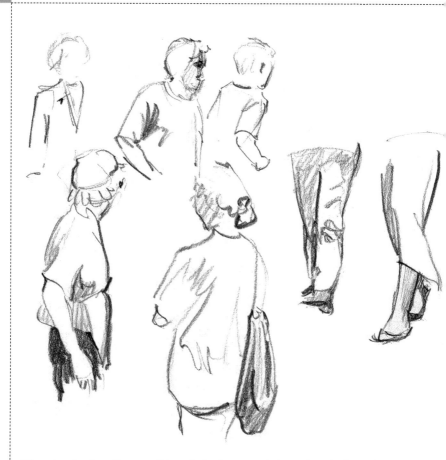

When drawing from life, you will have just a few seconds to capture the figure. Instead of trying to make a hurried drawing, draw an incomplete sketch. A good way to study the figure is to make a sketch of part of it: the upper half of the body, a silhouette from behind, a pair of legs walking, or some pants. To compose a figure, you can carefully join some of these parts.

that animate every corner. Here, you will learn how to make some simple sketches of figures with pencil and oil paint—small, quick sketches made with very few lines and strokes, with the goal of capturing the gesture of the model without becoming distracted by the details. In addition, we will show you the importance of the direction of the brushstroke.

a1. To sketch a figure in oil using dry brushstrokes with little paint, indicate the position of the head and the arms.

b1. Now, we propose sketching two figures chatting. Indicate the heads with blue and violet brushstrokes.

a2. Construct the body with a new brushstroke that mixes and blends with the brownish skin tones.

b2. Use thick paint to construct the bodies, a mixture of gray, blue, red, and yellow tones. The brushstrokes should be energetic.

a3. Leave the painting of the legs for last. You can apply new strokes of thicker paint to reinforce the arms and the face.

b3. All the parts of the bodies should look sketched, with some open areas where the support shows through. The direction of the brushstrokes should be very deliberate.

Architecture and **Chiaroscuro**

Conditions of weather and light can become very interesting subjects when they are approached from the point of view of a drawing—for example, applying shadows of charcoal and chalk that blur the edges and introduce a very strong chiaroscuro effect. It is one way of capturing a city in a version that is hard and less refined, but much more expressive.

***To begin, you can
use a very simple
model.*** *In this case,
we sketch a group
of very tall buildings
with charcoal. Blur
the lines by rubbing
with your fingers.
It should be a very
stark treatment.*

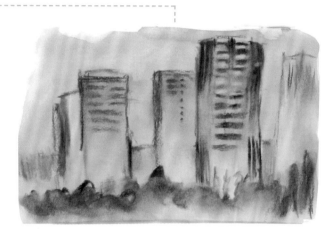

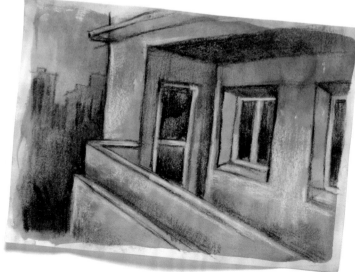

***Balconies and
other nearby
architectural
elements*** *also
form part of the
urban scenery.
Their simple
forms and lines
will allow you
to concentrate
on the heavily
shaded
chiaroscuro
treatment.*

A Drawing with Chiaroscuro

A drawing with chiaroscuro shading is an attempt to capture the instant of a glance, in which the shading and the different planes of light and shadow describe the forms of the urban space. The strength of the line and the intensity of the shading with charcoal cause the planes to stand out, with strong gradations and high contrast. The result is a drawing that stands out, that is very dark and not very appropriate for details, but with a great graphic strength.

The Drawing Process

Making such a drawing is very simple. Create an initial sketch with charcoal on paper that has first been tinted with watercolors. Draw loosely, using grays and shadows, and adjust the values with a combination of charcoal and chalk. Then, change the shading by rubbing with your fingers or a rag. Complete the drawing with white chalk, which will add contrast to the light in the sky and enliven the middle tones by adding light white strokes on the architecture. This will create strong highlights that increase the sense of volume in the drawing.

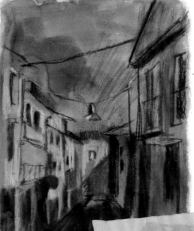

Charcoal, sanguine, and white chalk give the best results on a colored background, especially on neutral tones like grays, browns, and blues.

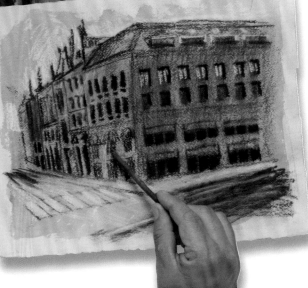

This technique will allow you to represent the buildings with strong lines and dark shadows—a treatment that is hard and not at all delicate. Although the architectural details may not be very precise, the results are quite expressive.

A Rainy **Day**

Cities can be exciting when they are influenced by a storm. The rain completely transforms them, and gives them new colors and a different atmosphere that blurs the buildings and strengthens the relections of light on the pavement. Here, you will see how to depict an urban scene on a rainy day.

The effect of rain can be created by diluting the watercolors and applying lines with a white pencil. This keeps you from seeing the forms of the buildings in the background.

Rainy days become gray, and the colors lose their saturation and intensity. You can barely distinguish the outlines of the buildings, and you see even less of the details on the façades.

Chromatic Range

The colors in the representation of a rainy city are different than those of a sunny day. Rainy days make the sky and the buildings gray, causing violets, blues, and even earth tones to appear. Even the strongest colors are deadened by the heavy clouds and rain in the atmosphere.

Blue, gray, and brown tones dominate, diluted in water or mixed with white.

Painting the Rain

Rain should not be painted, at least not in an obvious manner, although it can be suggested in a graphic form. The effect of rain can be created by blurring the edges of the buildings, at least those farthest away, and incorporating light, vertical, short brushstrokes, which will act as a sort of veil, or curtain of water, which blurs the model. The representation can then be completed by adding reflections on the pavement in the streets and on the sidewalks, which is absolutely necessary for the ground to seem wet.

A rainstorm can transform a quiet square into a dramatic scene dominated by blue and gray tones. The action of the brush is essential for loading the atmosphere with water.

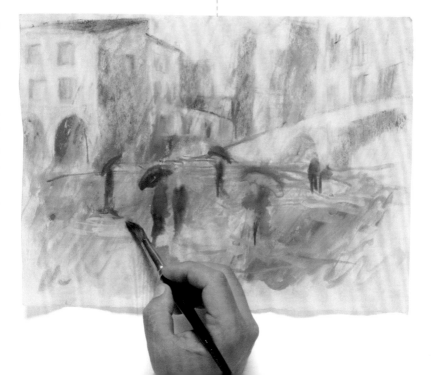

Automobiles and **Traffic**

One of the challenges of urban landscapes that most strongly attracts the interest of artists is the great number of contrasts that are created and the striking effect of movement generated by including people and vehicles. However, many artists avoid representing cars, because they are so difficult to draw. In the following section, we offer some guidelines to follow so this will not be a problem in the future.

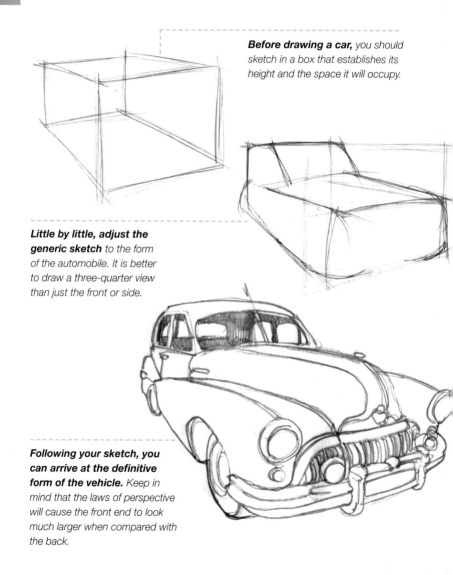

Before drawing a car, you should sketch in a box that establishes its height and the space it will occupy.

Little by little, adjust the generic sketch to the form of the automobile. It is better to draw a three-quarter view than just the front or side.

Following your sketch, you can arrive at the definitive form of the vehicle. Keep in mind that the laws of perspective will cause the front end to look much larger when compared with the back.

Vehicles Developed from a Sketch

When drawing automobiles, you should consider blocking in the shape for any model, because all vehicles can be developed from a simple geometric form. Place it in a box that will help you draw its shape. Starting with this preliminary sketch, which should be drawn in perspective, you should be able to easily draw old cars, with their voluminous forms and hard edges, as well as modern ones, with their organic and aerodynamic lines.

Textures and Highlights

The textures on cars are generally smooth, and they have metallic highlights. These are represented by using regular brushstrokes with little contrast, gradually moving from the brightest parts to the most shaded ones using gradations. The metallic effect is completed with some strategically placed highlights and reflections.

You must draw all kinds of cars: large, small, antique, and modern, changing the point of view so you can master them from all angles.

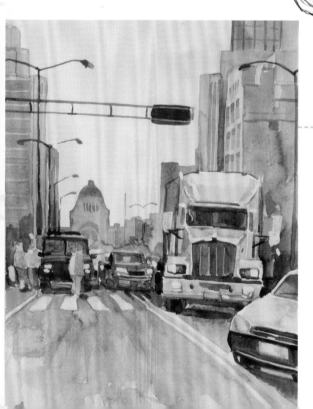

Many people are attracted to representations of busy streets full of traffic. This interest has resulted in a subgenre within urban landscape paintings.

Synthesizing the **Architecture**

Cities are dominated by geometry, the regularity of the contrasts in colors, and the changes in the intensity of the light. The buildings

This model shows interesting contrasts between the sunlit façade and the shaded one that is in the foreground.

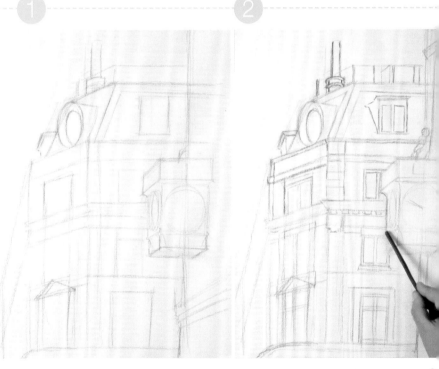

1. It is sketched with a charcoal stick, barely touching the support with the point. The sketch of the model is blocked in using geometric shapes that begin to relate to one another.

2. When working with the long charcoal stick, hold it at the far end so that the lines you draw are not too dark. Go over the initial sketch, drawing some of the aspects of the architecture of the building more clearly.

form a puzzle of shapes of different colors and sizes that are juxtaposed and overlaid to create a solid image of the model. In this exercise, the artist develops a theme constructed by accumulating brushstrokes of oil colors that synthesize the architectural elements based on units that are more or less planes of colors that complement each other. The treatment is very simple and pays little attention to details.

4. Work on the façade with two tones of gray, applying the lighter one in the more illuminated areas and using medium gray to define the outlines of the windows. Then, paint the roof with diluted cinnabar green.

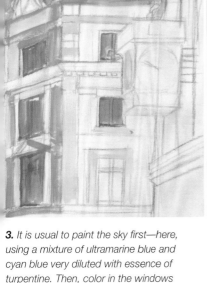

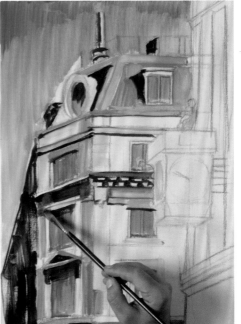

3. It is usual to paint the sky first—here, using a mixture of ultramarine blue and cyan blue very diluted with essence of turpentine. Then, color in the windows with gray blue.

5. Mix ultramarine blue and burnt sienna on the palette. The result will be a very dark gray that you can use to emphasize the darkest areas and also to suggest and contrast some architectural details with clearly painted lines.

6. Add some new gray tones to the façade in the background. Then, use a very diluted mixture of cinnabar green and violet, both grayish colors, to paint the building on the right.

7. Use a mixture of burnt sienna and cadmium orange to make a warm brown tone for the façade of the building in the background. Do not apply the color uniformly; it will look better with variations in tone. Then, sketch the clock in the foreground with diluted violet paint.

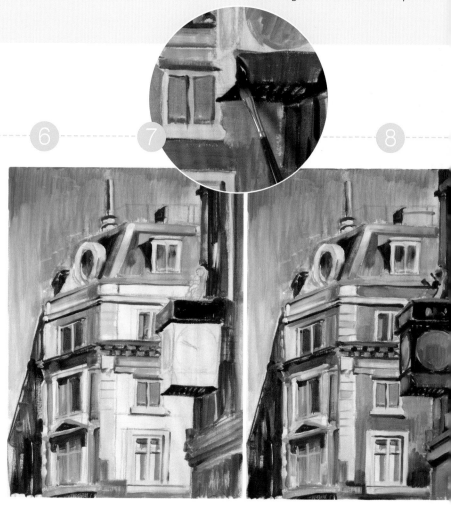

GEOMETRY DOMINATES THE CITY

8. The shaded building has a more solid look after painting over it with some strokes of thick, dense gray-green. The frame of the clock is then completed with a combination of whitened violet, dark alizarin crimson, and ultramarine blue.

9. There are only a few final touches: the railing around the rooftop of the building in the background, a few cables that hang across the street, and a very loose detailing of the clock face and its decorative elements.

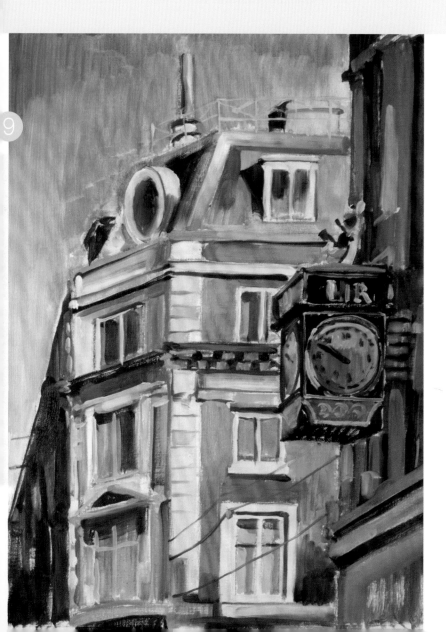

A Nocturnal **Landscape**

When night falls, the city is completely transformed. Sources of artificial light take the place of daylight, and give the façades and the streets a completely different feeling, with phantasmagorical shadows and gradations of colors that are not seen during the day. Inexperienced artists usually avoid nocturnal paintings, but the works on these pages demonstrate that they can be a very exciting motif.

Artificial light completely changes the look of the streets of towns and cities. The contrasts in light and shadow are harsher, and the atmosphere is more theatrical and dramatic.

The main attraction of a nocturnal scene is painting the rays of light that emanate from the streetlights, here brilliantly rendered with a gradation of yellows, oranges, and browns, done with color pencils.

The Harmonizing Effect of Artificial Light

Artificial light affects objects, not only modifying their coloring, but also the way they look. The explanation is that the dominant yellow, blue, or orange tone of the street light acts to alter the colors of the objects. This, instead of being an inconvenience, is an advantage, because all the colors of a scene tend to become harmonized when they are bathed in an orange or yellowish light.

Painting on Black

The best way of approaching a nocturnal scene is to paint on a dark background. Black cardboard can be used as a background for the composition, or you can cover the support a few days in advance with a layer of dark oil paint. The first masses of color should represent the illuminated areas, which are generally the most expansive, with a medium tone. The painting in this phase is quick and allows you to lay out the forms based on the main contrasts in the painting. The brightest highlights should be left for last and should be much more accurate and detailed.

The opacity of the oil paint allows you to paint in the buildings over a dark background, basing them on the light from the streetlights, the windows, and the storefronts that affect the nearby walls and façades.

If you are going to paint in oil over a dark background, you must be sure to make the preliminary drawing with a white pencil so that you can easily see the lines.

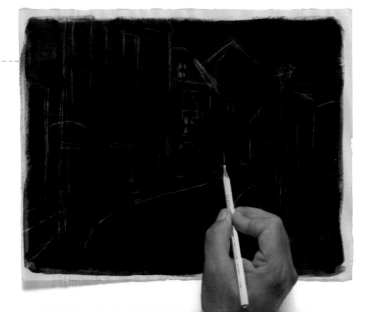

Industrial **Settings**

Many artists with an interest in painting urban landscapes avoid the downtown, the large plazas, and the parks, and head for the outskirts, the suburbs, and the places that contain industrial architecture. This type of work—which focuses on manufacturing sites, shipyards, foundries, water towers, and dockyards—is a subgenre with a few distinctive characteristics.

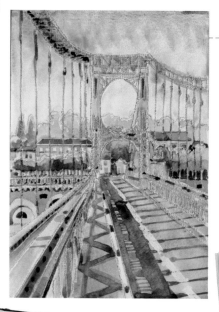

Steel bridges *are works of engineering that offer the artist an opportunity to apply an interesting graphic composition, based on geometric structures, to create a strong visual impact.*

Dockyard scenes are vey common, *because the enormous cranes that are used for loading and unloading the ships are very interesting to painters.*

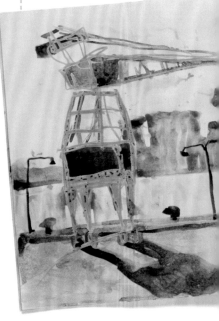

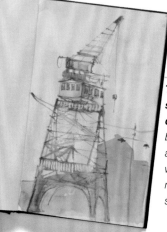

The cranes seen at the dockyards *can be drawn using a combination of washes and lines made with water-soluble pencils.*

An Echo from the Past

The iconography of industrial architecture experienced an extraordinary boost in popularity after the introduction of photography. In many paintings, it is represented as an echo from the past, as a structural form with a simple architecture that is stripped of superfluous ornamentation and that communicates a sense of speed, strength, energy, and rationality. Many artists prefer to depict it in a state of abandonment, as if it has been dehumanized, leaving only a memory of what it once was.

Rhythmic Structures

Painting industrial architecture is all about recording your impressions of the culture of work on the canvas. The artist usually focuses on praising the technical advancements of this new architecture, showing his or her preference for the industrial aspects related to making iron and steel, metallurgy, trains, and dockyard scenes, because they are visually rich. The scenes are constructed with forged iron and steel supports that look like mechanical skeletons dominated by geometry, rhythmic structures that have very interesting compositions.

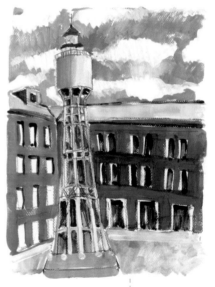

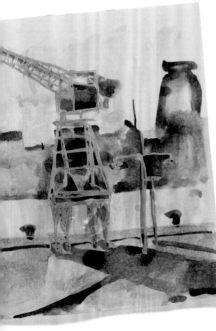

Some industrial symbols *become objects of great beauty—for example, water towers can be an interesting contrast to traditional architecture.*

THE SUBJECT

Lights, Bars, and Terraces

Cafes, bars, markets, and public spaces where people gather to converse and socialize are very interesting subjects, because they contain a variety of colors, forms, and even lights that offer a range of different colors and textures. It is important to capture this atmosphere and communicate the sensations radiated by these places using visual clues.

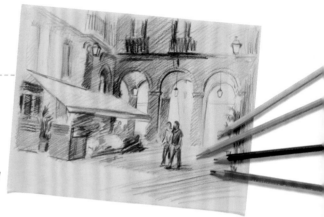

*Including places
where people
socialize* animates
a painting or drawing
by combining street
furniture and figures
within the architectural
framework.

When you paint a street *with bars and
terraces, you should never begin with the
figures. You must first resolve the play of
lights with gradations and blended colors.*

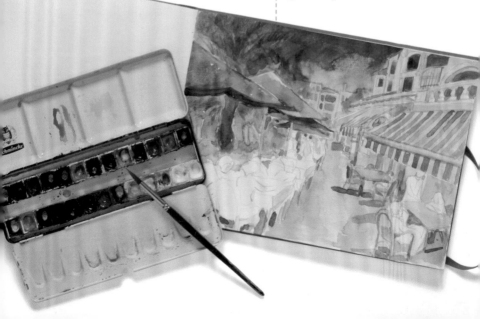

A Good Drawing

It is not enough to represent the effects produced by artificial light coming from inside the businesses or that filters through the colored awnings. You must also include the figures and furniture in the scene. When there are so many factors involved, it is essential to make a more developed drawing that represents each element carefully, but without adding too many details. In other words, do not attempt to make detailed portraits of each one of the figures in the painting.

Ambient Light

The pre-painting is the most important phase of this type of work, because the goal of the first applications is to capture the ambient light, the dynamic colors of the scene. To do this, the first applications of paint should be blended to create an ever-changing atmosphere, with rays of light that mix and overlap. The figures will appear to be tinted by the same colors. If you are working with watercolors, it is a good idea to add small touches of color on wet to create a surface that is less uniformly rich in color.

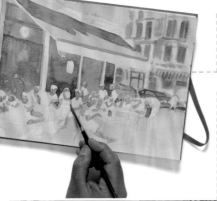

Paint the atmosphere first—in this case, with a clearly dominant red that comes from the strong light that filters through the awning and tints everything the same color.

The colors of the figures should be related to those used in the pre-painting, that define the atmosphere, with the goal of creating a color harmony and transmitting a feeling that the figures are all participating in the scene.

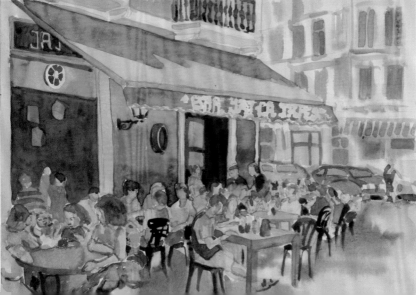

Nocturne **in Oils**

Light transforms urban spaces into a theatrical scene where the figures are barely perceived shadows that seem to be wandering around.

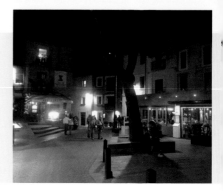

1. *The first step is a pencil drawing, which is very important when representing a space in perspective. In this case, pay close attention to accurately rendering the angle of the windows.*

2. *You do not need black to paint the sky; it can be darkened with Prussian blue directly from the tube. Try to work around the tree and indicate the outlines of the rooftops.*

3. *Add strokes of green paint on the tree that do not completely cover the white of the support. Then use various blue and gray tones to paint the tree. The colors should be blend with each other to create gradations.*

When night falls, the signs on the businesses light up and the rays of light project interesting colors on the sidewalk and the pavement. The buildings emerge from the dark blanket of the sky, creating an attractive play of contrasts between the projected shadows and the blue and yellow tones of the neon lights. In this exercise, we will paint a small square bathed in the light coming from the nearby businesses, using just acrylic paint as the medium.

THE COLORING OF RAYS OF LIGHT

4

5

5. Do the same thing on the ground, using a range of whitened pinks, blues, and violets. In nighttime scenes, you can indicate the ambient light by using wide strokes of paint.

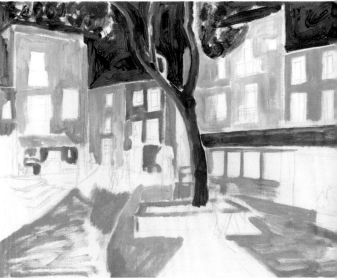

4. Paint the façades with different, slightly graded colors, to recreate the effects of light on them. The windows should be left white. Use quick, light brushstrokes.

6. Notice that blues and violets are the colors selected for representing the areas in shadow, while warm colors are used on the illuminated façades.

7. Now is the time to paint the openings: use light tones for the ones that have lights inside and violet black for the dark windows. The window frames should be left white.

8. Add new layers of paint on the façades to give them more solidity and shades of color. Use the same dark violet from the windows for lines that better define the awnings and the entrances to the cafes.

9. The people are just silhouettes, almost paper dolls, which are not in proportion to the distance that they are from the viewer. Linear brushstrokes should be used to define the balconies and marquees.

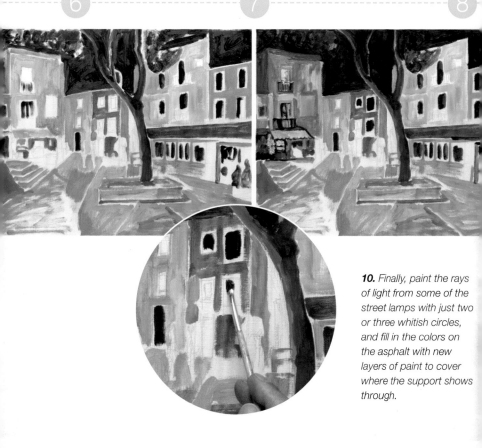

10. Finally, paint the rays of light from some of the street lamps with just two or three whitish circles, and fill in the colors on the asphalt with new layers of paint to cover where the support shows through.

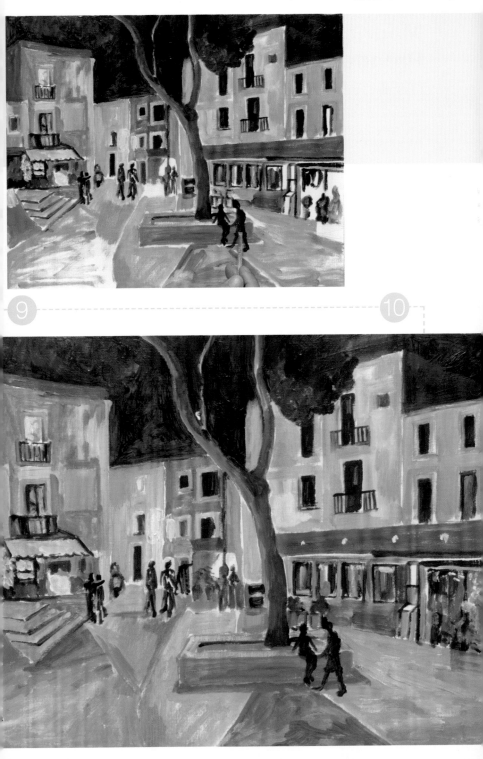

Maurice Prendergast
(1858–1924)

Prendergast became one of the first American painters to make use of expressive colors and forms.

A Street In Rouen, *1894.*
A few figures are arranged against a clearly architectural background, painted in a few barely defined strokes of bright color. A single watercolor brushstroke renders the pose that distinguishes each figure, avoiding the faces, which he leaves unpainted, while the bodies are indicated using the color and volume of their clothing in a schematic arrangement. His work is characterized by bright and lively colors applied in dots or short brushstrokes, combining areas of colors that float and disappear next to each other, revealing the influence of the Impressionist and Postimpressionist painters.

1. The following watercolor shows Prendergast's simplicity and delicacy. The model is drawn in pencil, with a very light line so that it will not show through the washes.

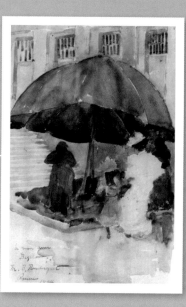

2. Next, he approaches the architectural setting with very light watercolor washes. He leaves small white spaces between the areas of color to keep them from mixing.

3. It is surprising how simply the artist indicated the architecture, combining browns with Payne's gray. A figure lies beneath the arches, painted with a monochromatic wash that is used to represent the shaded areas.

4. More water is used when mixing the colors for the foreground and on the ground, which are both much brighter. The second figure is left unpainted.

Prendergast was a Postimpressionist painter from the United States, although he was born in Canada. Unlike his contemporaries, who preferred oils, Prendergast worked almost exclusively in watercolors. Influenced by the work of Eduard Vuillard and Pierre Bonnard, he created paintings with large areas of radically simplified color. In 1898, he traveled to Venice, and the effect of this city's urban environment inspired in him an admiration that can be seen in a long series of works dedicated to illustrating life in the Venetian plazas and streets.

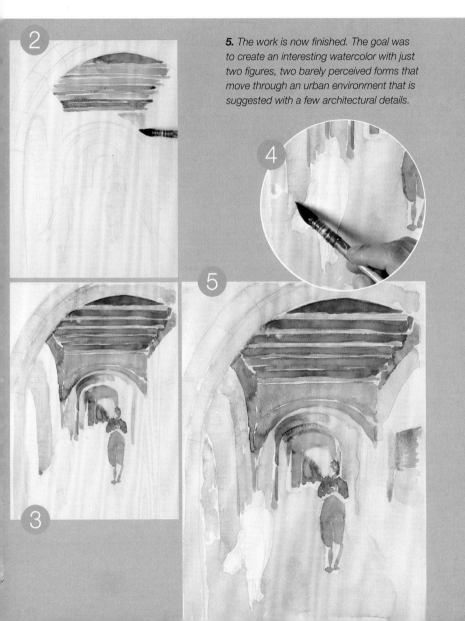

5. The work is now finished. The goal was to create an interesting watercolor with just two figures, two barely perceived forms that move through an urban environment that is suggested with a few architectural details.

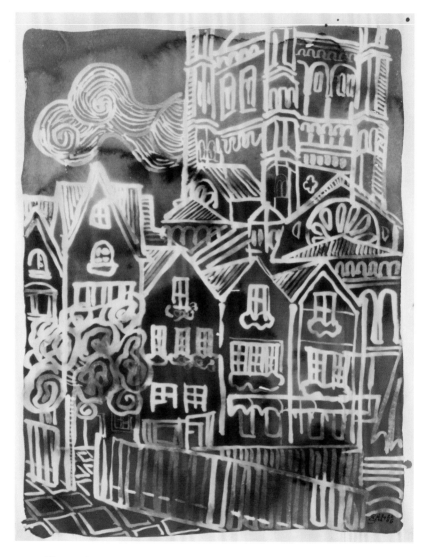

"A street is not made up of tonal values, but is something which bombards us with sizzling rows of windows and humming rays of light dancing amidst vehicles of all kinds, a thousand undulating globes, the shreds and fragments of individuals, the signboards, the roaring tumult of amorphous masses of color."

L. Meitner, *Instructions for Painting Pictures of the Metropolis*, 1914